Cricut Maker

The Ultimate 2021 Beginner's Guide To Master Skillfully Tools And Features Of Your Cricut Machine + Step By Step Illustrated Practical Examples And DIY Projects Ideas

BRITNEY PERKINS

Additionally, the information in the following pages is intended only for informational purposes and should thus be thought of as universal. As befitting its nature, it is presented without assurance regarding its prolonged validity or interim quality. Trademarks that are mentioned are done without written consent and can in no way be considered an endorsement from the trademark holder.

.

Table of contests

Introduction

If you are not familiar with the Cricut machine so far, then this book will introduce you. You're going to get familiar with one of DIY's favorite crafting tools. This is called the amazing Cricut machine. This machine can be used to cut, perforate, deboss, engrave, and draw images on many different materials. You can do a lot more with this machine.

The book has all the information on Cricut machines that newbies require to learn about this amazing device and to make full use of it. Comparison between Cricut machine types and providing you a verdict about which is the best one is also a part of this book.

Chapter 1: Cricut Machine and Its Working

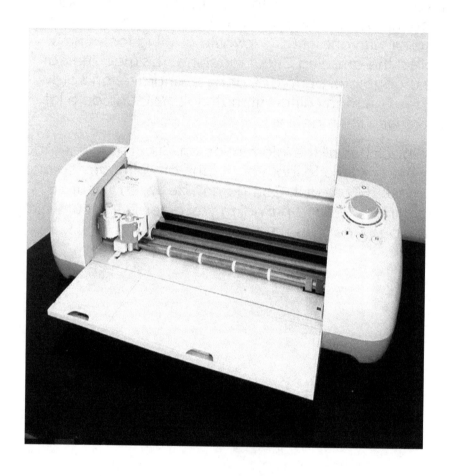

1.1 What Is a Cricut Machine?

Cricut is a brand name of a computer device that cuts a range of products, including paper, hard card, and vinyl stickers, and, in case you have an advanced version, you may cut fabrics. It works through an online software, that is known as Design Space. Using this, you can purchase, upload, or build your plans, and this device can cut it for its owners. It also holds a good feature called "Print and Cut" that helps you print your template on a standard home printer and then put it into the Cricut device to be cut according to size. Additionally, for cutting, you may also buy extra tools that enable your device to compose fancy calligraphy, perforate beautiful lines or engrave intricate designs.

In reality, if you wish to use Cricut as a printer, the good news is you can do that as well! There is a dedicated accessory slot available in your machine where you can load any marker (designed for this machine), and this machine will "draw" any template for you. Sometimes it's perfect to have a beautiful handwritten feel if your writing style isn't very good.

1.2 How Does Cricut Machine Work?

The Cricut functions like a regular printer by shifting a blade or a pen towards the horizontal axis (edge to edge), whereas two wheels shift a mat along with the desired content towards the vertical axis (forward and reverse).

You may attach the Cricut device with the computer wirelessly, build or import designs on your computer, and return these to your Cricut device for cutting. Cricut device has an app named Design Space (easily available for Windows Operating System, MAC Operating System, and Smartphone Operating System) that helps you build and import templates that can be cut using your device. The Cricut device has a small blade (either rotary blade, pen, or scoring tool) inside. If your design is ready to be cut in Design Space, then you can lock your chosen material on a 12-inch broad cutting pad, submit the said design from your desktop to your Cricut device wirelessly. After that, you will be able to load the material into the machine. Pressing a button would start cutting the project.

Essentially three steps must be followed to use the Cricut device:

1. Create Your Design

To create a design, you can use the Cricut Design Space free application for your Computer or Mac Operating System. You can use the Design Space application for the iOS operating system while using your iPhone or iPad device, or the beta edition of the Design Space application for Android is easily available. Design Space is a software that links your computer system to your Cricut device. Cricut Design Space application library is filled with thousands of pre-made templates available to be imported and rebuild by yourself.

You can create the project the same as you have planned it or modify it if you want. When you select a Design Space Library project, you'll see choices to modify it (then you can adjust it, optimize text, etc.); further, you can build a brand-new concept from Scrape inside Design Space utilizing their designing software. You can edit text, pictures, upload your photos, resize, change the design, etc., to build an ideal design. When your project looks as you wish it to be, that's the time to prepare the Cricut device.

2. Make Your Cricut Machine Ready for Use

This is a super easy step. Switch your machine on. OK! But seriously, it's so easy! You don't even need to load content or bother to adjust the dial; leave anything at the current level; the application will show you detailed guidance for all matters.

3. Transfer the Design to Your Machine

The final move is to submit the task to the Cricut device. Once you're satisfied with your model and your device is turned on, click the wide green-colored "MAKE IT" button at the upper right side of the Cricut Design Area. The software begins with an overview of your various mats. Every mat is a single sheet of paper, and in that case, where you have three multiple colors for your project, you have three multiple mats. If you are using paper and cloth for a design, then you will also have a single mat for each material.

The first step that is mandatory to do on the screen is to set the limit you want to remove (if you're trying to create two cards, then order it to create 2 Project set at the top left corner). 12" x 12" size is normal for many of the product you're going to remove, so if the product is in different sizes, adjust the product size to represent it properly. If you're going to create an iron-on model, then flipping or Mirror is essential to accurately reflect the completed product. Press Proceed at the lower right corner until you set certain parameters, and you are ready to submit the model to your Cricut. After this, the next part will help you in setting the dial as well as loading your supplies.

1.3 What Is This Machine Capable of Doing?

You will use this device to create so many things and transform your art concepts into physical products because the Cricut Maker is a complex machine that manages various materials, allowing the consumer to cut into sophisticated patterns and models. The Cricut works with balsa wood, leather, cloth, and paper, including 300 separate materials that can be sliced with exceptional accuracy. A range of add-on resources can be bought for Cricut, which allows it to manage many other tasks and craft projects.

For those who like creating crafts and presents at home, the Cricut is the only device that can give a lot of fun. Just consider bringing in a new art project day by day. Each of the projects is different from the last one. That's why artisans and DIY fans enjoy this thing a lot.

If any Cricut user is waiting to utilize his/her skills from home or discussing usage and whether this product is worth its cost, we've identified so many different items that could be prepared with the help of a Cricut maker. Many of them are good for children, others will be great gift concepts for elders, and all of these are within your reach, thanks to this amazing machine.

Wood Signs

Everyone can become an excellent woodworker with the help of Cricut. It will not be the same thing as the major stores, but it is still unbelievable. They will create gorgeous holiday presents or send them to someone special on his/her birthday.

Paper Flowers

Several events are made very stunning and unforgettable due to the arrangement. The paper flowers will always look awesome in the entire show. No more stress because you can create them by your hand or attempt to trace down the same color available on the internet or in a shop. With the Cricut machine, it could be a different color or scale. The requirement is just a little creativity.

Designing Labels

There is always something really beautiful and calming about the house that's thoughtfully planned out, arranged, and where everyone has its location. With the Cricut device, all the product labels will be much better-looking and fancier than we have ever considered. This can be presented in a very easy and modern manner or done in a unique style.

Iron-On T-Shirt

We've also noticed that so many T-shirts with cool sayings on social media are available, and we waste hours searching the internet to locate them for ourselves and our children, then closing down the browser after finding that the effort is pointless. Ok, now with the Cricut, parents will design their T-shirts having cool sayings on them.

Reusable Stencils

Stencils are useful for all art and decoration projects, whether they create presents or try a different decoration method at the house. The Cricut machine can create those types of stencils which can be used again and again. It makes them with absolute accuracy.

Faux Leather

Yeah, this Cricut can manage leather and synthetic leather, too, so think of all the interesting craft that can be made. Artificial leather ear-rings seem an outstanding sample of a small art project. This can be created almost in any style. If any concept has been floating around in your mind for some time, this is the easiest method to adopt and wear it into routine life.

Homemade Puzzles

It could be very interesting to have a puzzle quiz for our children with their names printed on puzzle pieces. This is one of the lovely crafts that can be done with the Cricut machine, and it's not very hard or difficult to do the same we are expecting. It can be colored later on to enhance the level of beauty and customization.

Rubber Stamps

There's a lot of enjoyment when making rubber stamps. Most of us remember playing with kid's stamps and how much fun we had with them. Many stamps can be bought for people who enjoy scrapbooks or other projects. It's just one, and many items can be created with the Cricut machine's help—and think about the enjoyment that we can have by creating custom stamps!

Chapter 2: Comparison Between the Cricut Explore and the Cricut Maker

If you already have Explore Air 2, don't feel you need to update instantly. It's something like when the next iPhone is released, and you might get taken by all the excitement of the revolutionary features, but the existing one always runs perfectly fine.

If you like the new and best functionality, you should update, but don't think it's a must, the Cricut would not quit helping while working with the current device.

However, we are going to accept that Cricut has made the most advanced version, and you totally love it, so you're certainly not going to miss it when you can afford it. The manufacturer is now beginning to go on sale offer since it was first launched, so it is time to start planning an update if you've been worrying about updating.

2.1 Cricut Maker's New Features? What Can It Do That the Explore Can't?

However, we will accept that Cricut has made the most advanced version, so you're certainly not going to miss it when you can afford it. The Manufacturer is now beginning to go on sale offer since it was first launched, so it's time to start planning an update if you've been worrying about updating.

It has a rotary blade that cuts fabric and styles in a better way than Explore Air 2! Because this is surely the Cricut machine's legend and a wonderful improvement compared to the previous models. The rotary blade trims hard materials such as felt and cloth perfectly (You will be surprised every time!). You never had a texture before either because your texture has always been a pain with inconclusive results on Air 2, and now with this Maker, it's your best materials to trim!

To make clear, about the Explore Air 2 capability to trim the cloth, it always requires a backing and a stabilizer like Warm air n' Bond added to the cloth when matting is nowhere effective as the blade starts pulling on the cloth but does not give it neat cuts just as a spinning rotary blade machine.

During "Print and Cut", you can also use colorful or patterned material. Is that life-changing? Never, no. Good to get it? It's absolutely the way I'm thinking about doing this is same; you can print a design like Joyful Valentine's Day by using on a sweetheart template paper; then, cut around the template. You don't spend your ink on printing white paper backdrop, which is awesome.

The knife blade helps you trim with 10x more strength and a stronger (above to 2.44mm thinner) coating. If you want to cut wood with your cutting machine, you need to purchase a Manufacturer.

Easy Extendable Tool System

This special word essentially implies that the Creator was made to evolve with someone as a craftsman and match up an entire range of new resources that the Cricut machine has on his sleeves. You've heard reports that there are more than 40 different blades they're talking about making. So, if it bums you out not to be allowed to use freshly launched attachments and cutters, go for the maker.

The Physical Design of the Cricut Maker

Charging port and device monitor holder—helps you charge and show the phone or iPad conveniently while creating designs.

More capacity for devices. The Maker also has 2 storage cups and a bigger storage cabinet.

Get free from the smart dial to choose the material type: initially, you can quickly make some material adjustments from your screen when you set up a cut-out pattern. Moreover, it educates you on using a broad range of custom products instead of only those that match the smart dial. There is no cartridge port in the machine. If you're a long-time customer of Cricut machine and have a cartridge of your older device, you need to purchase an adapter to be able to use these with the Manufacturer. You don't even think about this with new users who haven't owned a Cricut previously.

Which Cricut Variant Fits Your Needs?

Comparison	Cricut Explore Air 2	Maker
I plan to mostly create...	Paper + Vinyl Projects	Paper, Vinyl, Home Decor, and Sewing Projects
Are you on a strict budget?	Yes (Usually on sale for $199)	No ($399) Brand new so no sales yet
Which would describe your interest level and how often you'll use it?	I'm a casual crafter. I'll probably make a few projects per month and nothing too complex.	I am a serious crafter or business and plan to use it often. I want to be able to cut thicker materials & fabrics.
Will it upset you if you can't use newly released blades + accessories?	No, I like to keep it simple and I have all the capabilities I need.	Yes! I want to be able to get the latest and greatest tools & projects!

2.2 A General Verdict

Cricut Maker

Cricut Maker is one of the best cutting machines. It appears to be comparable to the Discover machine line, but this has been re-modified from the ground up. It does all that Cricut Explore does, along with additional features. Cricut Creator cuts unbound cloth (therefore, you shouldn't need a stabilizer like the Cricut Explore line) using a tiny Rotary Cutter. It often makes you smile wonderfully, so if you're trying to make felt crafts, this is your unit.

Cricut Maker often removes thicker items (up to 3/32"), including balsa wood and soft leather with the Knife cutter. It will rate all kinds of materials by using Score Circle.

Cricut Maker's Adaptive Kit is designed for extension in the brain; it was designed to use materials that Cricut still hasn't dreamed about! They have a couple of additional resources to test—so this machine can do extra as additional features are published. The price point seems to be the strongest upon Cricut line $399, often on contract for $349. If you're a professional craftsman who wants to use many tools, and if you're a stitching lover, an ardent paper craftsman, or maybe a woodworker, this device is for you. Good FOR: Craftsmen who want it and especially those who cut cloth or cut thicker items

Makers Capabilities

Cricut maker cuts a range of products, including paper, hard card, and vinyl stickers, and, in case you have an advanced version, you may cut fabrics. It works through an online software, which is known as Design Space. Using this, you can purchase, upload, or build your plans, and this device can cut it for its owners. It also holds a good feature called "Print and Cut" that helps you print your template on a standard home printer and then put it into the Cricut device to be cut according to size. Additionally, for cutting, you may also buy extra tools that enable your device to compose fancy calligraphy, perforate beautiful lines or engrave intricate designs.

In reality, if you wish to use Cricut as a printer, the good news is you can do that as well! There is a dedicated accessory slot available in your machine, where you can load any marker (designed for this machine), and this machine will "draw" any template for you. Sometimes it's perfect to have a beautiful handwritten feel if your writing style isn't very good.

The Explore Air 2

This is a great powerhouse machine—it will cut cardboard, faux leather, suede, Cricut felt, and even more than a hundred other products. It cannot cut the heavier fabrics that the manufacturer can, but it's a great machine for most artisans. Moreover, it has a lot of colors, suits every craft room as well!

BEST FOR: Many consumers want to cut common materials such as iron, vinyl, and cardboard.

(Verdict) It's the best long-term plan as you will also get a lot of usage out of it; furthermore, it can function for all the newest and greatest updates and add-ons that Cricut launches. There's no doubt that these devices are pricey, so it's better to purchase one that's going to you; the last also has the power and flexibility of what you can cut with it! With the help of Cricut Maker, you can also cut silk, felt, wood, and leather a lot more than you ever did with this series of devices—I've been blown away!

Furthermore, it's been beginning to go on offer lately, so you can get some amazing offers on it by having an Explore series like this and looking to update.

No matter which variant you use, you can still attach the Cricut units with the computer wirelessly, build or import designs on your computer, and return these to your Cricut device for cutting. Cricut device has an app named Design Space (easily available for Windows Operating System, MAC Operating System, and Smartphone Operating System) that helps you build and import templates that can be cut using your device. The Cricut device has a small blade (either rotary blade, pen, or scoring tool) inside. If your design is ready to be cut in Design Space, then you can lock your chosen material on a 12-inch broad cutting pad, submit said design from your desktop to your Cricut device wirelessly. After that, you will be able to load the material into the machine. Pressing a button will start cutting the project

Chapter 3: Designing Projects Using Various Materials with Cricut

The Cricut Maker machine is an updated version of the die-cut machine. This strong machine is incredibly flexible and can carve, score, engrave, and inscribe many products, varying from balsa wood pieces to paper labels or silk. It also works well with countless fabrics. The Cricut Maker may even draw fonts, forms, and more using its cartridges. You can build countless designs with the support of Cricut's resources and the Design Space application. The Cricut Maker, no doubt, is a must for those who regularly create DIY projects for them, no matter if there are for personal use or business use.

3.1 What You Can Design and Make Using a Cricut Maker

The Cricut system's versatility has improved through the years; modern versions have been more powerful and adjustable during their starting years. Although many assume the Cricut machine is mainly used for scrapbooks and the card-making process, this machine's versatility goes far beyond personal crafts. Most small business owners depend on Cricut to build beautiful designs for their companies.

The first significant change in the Cricut machine is that Cricut Explorer has a huge cutting force of up to 10x-4kg. It's better than several industrial cutting equipments! What does this suggest for the typical consumer? You can also cut heavier and thicker fabrics more quickly, like leather, chipboard, and balsa wood more than 3/32" thick.

It may even cut the finest of fabrics, such as crepe paper. What's more, you may cut cloth! All this, and it proceeds to cut wonderfully the papers, vinyl, and other fabrics that Cricut Explore has already cut. Here are articles on the cutting of maker-only items:

- Light Basswood pieces

- Hard Chipboard

- The Matboard for Cricut

- Artificial and hard Leather

- Hard and soft Fabric

Hence the 2nd enhancement is the convenient Adaptive Instrument Device program. Your Cricut has much more influence over the instruments, utilizing sophisticated, complex equations and a series of complex brass gears built to boost cutting accuracy. The convenient Adaptive Tools Framework helps Cricut build innovative technologies presented once they have been invented. For example, the Knife Blade and the Score Wheel are two additional items that have been introduced since its launch, moreover to the Rotary cutter that comes with the Manufacturer.

Other changes involve a power socket for your mobile or iPad when working on your projects and a USB connector for charging certain phones (this USB port would also control equipment at the same moment!). The kit capacity of two tool cups having a bigger storage container has been enhanced

What Does a User Need to Begin Designing the Projects Using a Cricut Maker?

When designing a project, the concept requires the right computer to come alive in vibrant color and stunning information. With Cricut Maker, you'll also get an outstanding smart cutting machine filled with all the helpful features you have to carry your template to life with beautiful performance. With its adjustable suite of equipment and specialized rotary and knife cutters, the Cricut Maker offers you the ability to deliver virtually every DIY project with total simplicity and accurate performance. This fun and flexible machine cuts dozens of fabrics, from the finest cloth, paper on the mat-board, and leather, so that you can make a broad variety of pieces and models without concern. It's expert cutting output, open for everybody, and one of the most respected and popular brands in the industry. You need to install the software that uses the Design Space App. Design Space app allows you to post your templates or select thousands of fonts, photos, and make projects inside the Cricut machine.

You may also use Cricut Maker to build and arrange your home by creating vinyl labeling for plastic space containers and labels for cloth storage containers. On top, you could build 3D designs from some different products, from the Kraft Board into Bass Wood. You created your first 3D projects in the week, like a tiny box ideal for presents or storage! Lots of pre-made models are eligible for use with the creator. When you discover a project that you enjoy, you can make it with the same materials seen or customize in your way. Generally, you can also use this computer to create a lot of projects within a minimum duration, you only need to spend some cash and your precious time, with the passage of time and execution, and you can astound your friends and relatives too with your expertise.

Cricut Maker Accessories

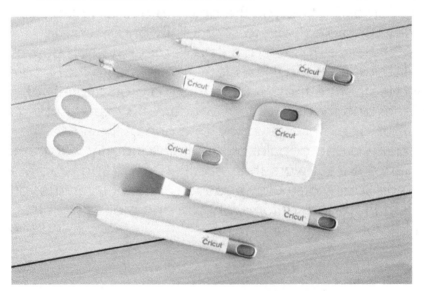

Although the Cricut does not need much beyond the unit, the cutting pad, and the cutter, there are already many valuable resources that can help you make the most of your Cricut. There are few areas to start knowing about the equipment and gadgets you should buy for the Cricut. Most of these articles are relevant for the Cricut machines, but it will highlight them when you get some of the Cricut Maker materials.

Chapter 4: Tools and Accessories that Are Essential to Work with Cricut

After deciding which Cricut Machine goes exactly according to your needs, the next move is always to determine the Cricut tools you own? Let's see, if cash grew on leaves, it would be an easy answer... one of all, yes! Then we have to nail it down in a practical world. That implies that our very favorite novice must-have accessories for Cricut Builder. So this section will examine the equipment and gadgets you need to operate with your Cricut device to get the best out of it.

4.1 List of Cutting Materials Compatible with Your Cricut

Vinyl

Vinyl has been used for many tasks, from wooden signage and car decals, and clear stencils for art projects. These types of vinyl may be included in several projects.

Iron-on

Iron-on, also called Heat Transfer Vinyl, is used to adhere vinyl and in heat projects or objects. This may involve everything from t-shirts as well as bags, wooden signatures, and leather earrings. Usually, Iron-on vinyl remains particularly flexible.

Paper

Many artisans used Cricut cutters as they want to produce pretty papercrafts. From homemade cards to simple birthday decorations, you can easily try many other wonderful Cricut cutting materials.

Fabrics

You enjoy using Your Cricut machine to cut off the fabrics!! It's quick, fast, and precise for both Cricut Explorer and also the Cricut Maker will cut the cloth. The Explore includes the bonded blade of the Cricut cloth. The Cricut Maker requires a rotary cutter.

You're limited to the Explore fabrics; however, it allows you to cut the fabrics. Find out a little more about the Cricut Rotary Blade machine to show you a little bit about cloth cutting.

There is a lot of material that can easily be cut with Maker besides the items described above. You will require extra blades to cut with the maker since a single blade cuts various equipment pieces.

- The Balsa Wood pieces
- The Distressed Crafts Foam

- Birch Craft Foam

- Basswood pieces

- Hard and Light Chipboard pieces

- The Magnetic Papers

4.2 Accessories: Most Common Accessories for Using with Cricut

1. Scoring Wheel

The Ranking/scoring Wheel is a combination of the kit that includes a single score line 01 (for cardstock) and a double score line 02 (is for special materials like acetate, foil poster board, etc.). They're going to give you cool crisp folding lines. Even more than simply having the Score Style.

2. Weeding Tool

The Weeding Tools are ideally adapted when you're working on cutting Vinyl, Iron-On (Heat Move Vinyl) with the Cricut Builder. These techniques allow you to extract unnecessary bits when you cut (that type of "weeding").

3. Sewing Kit

The Cricut Sewing tools are the perfect companion tool kit unless you're trying to cut cloth using your Cricut Builder. It contains 8" Cloth Scissors, Thread Snips, Seam Ripper, Cute Cricut Creator Pin Cushion, Pin Collection, Measuring Tape, and Leather.

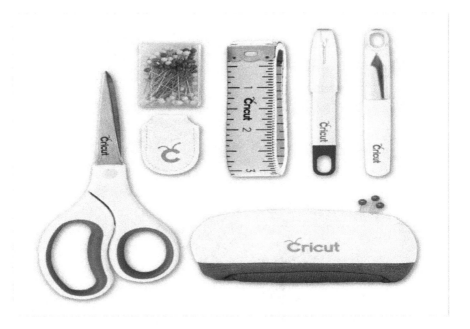

4. Scraper & Spatula

Here's the Scraper & Spatula, and it is used to help you lift small cuts made with Cricut over the mats. They're certainly a must for any of the kinds of craft you're going to do with Cricut Maker.

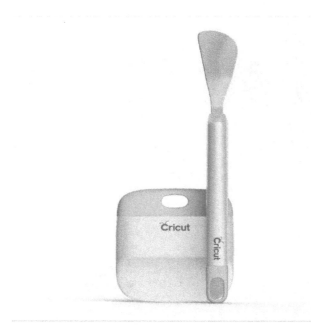

5. Pens

You can easily do this with Cricut Explore devices' help, too, and it's a pretty cool trick. If you'd like to compose terms that look like the script, you will need to use those fonts which are single line. You'll also get bubble letters in several of the fonts. Often they look sort of neat, and that's the look exactly you're aiming for, come on! Instead of that, make sure you use the Graphic Space filter to select "Writing" fonts. You will utilize Cricut Pens to sketch an image. Intricate sketches like mandalas are coming out looking great!

Today, you can also get Infuse Ink Markers and use your Cricut device to draw your designs that will last a decade!

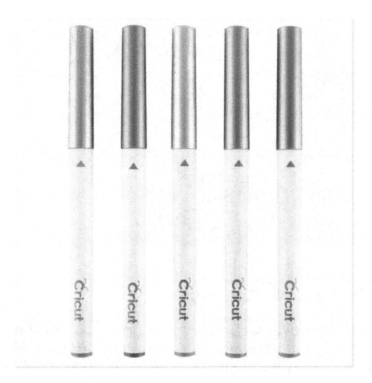

6. Cutting Mats

Usually, the Cricut Mats are a vital aspect of operating your Cricut Maker if you want to keep spares on hand like they were out based on your use. You normally have 1 Light Grip (includes Blue Mat) and 1 Cloth (includes Pink Mat) for your Cricut Builder. Choose the spares depending on the kind of products you use for Cricut Maker. Mats are available in the size of 12X12 (most common) and 12X24 styles.

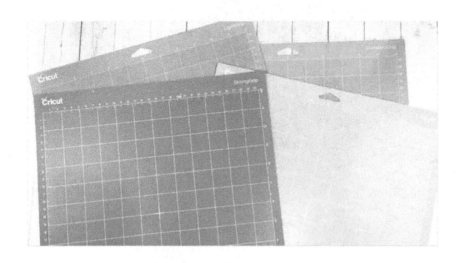

7. Brayer & Remover

Brayer & Remover Kit is very important if you use the Cloth Grip Mat quite much. It's the strongest weapon to guarantee that the cloth holds down reliably to have the right cuts that you'll use.

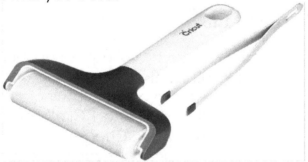

8. Cricut Iron-On

The Cricut Iron-On device is exactly what you need to produce t-shirts, canvas bags, aprons. You may also use it for timber. It comes with a range of shades and specialty styles—pattered, foil, shimmer, etc. You may require a heating element to use Iron On/Heat Move Vinyl.

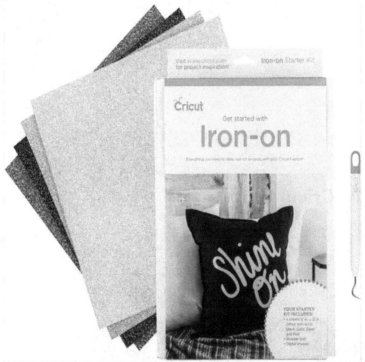

9. Chipboard 2mm

The Cricut Chipboard 2mm is a especial chipboard intended to be used along with Cricut Maker Knife Cutter. You're still going to need a Firm Grip Pad-Ideal for making concrete wall art, picture frames, school assignments, decoration, and puzzles.

10. Cricut Fabrics

Cricut Fabrics is perfect for cutting with the help of your Cricut Maker while using the Rotary Blade, which comes with your Cricut Unit. There is a broad range to pick from Designer Clothes, Pre-Cut Cloth, and Quilting Kits.

4.3 Blades Used with Cricut

Based on your Cricut unit, you're going to need a range of blades that help you achieve the perfect cut for your products! Below are the various blades that you will use for your Maker and their different applications. Not all will be addressed, but the most widely used ones are mentioned here below with some information:

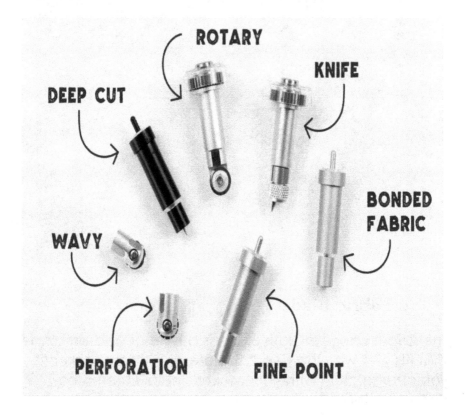

1. Fine-Point/tip Blade

The Cricut machine Point Blade is a regular blade that comes with the Cricut Explore and Cricut Maker. It was once regarded as the "Higher price German Carbide Cutter."

Modern Cricut machines have the housing for such a blade, but it is doubtful that you would need to purchase a new housing, although removing the housing could be an alternative if you have severe problems.

2. Fabric Blade

The Cricut Bonded Cloth Blade is a type of add-on blade that fits well with the Cricut Explore and Cricut Maker (if you cut the cloth with your Maker's help, I prefer the Rotary Cutter).

3. Deep-Cut Blade

The Cricut Cutting Blade is also an add-on blade that fits well with the Cricut Explorer and as well as for Cricut Maker. It is designed to be used for heavier materials than the Fine-tip Blade and utilizes a particular angle and cutting depth for the tougher materials. You're going to need to purchase this blade as well as housing individually.

4. Rotatory blade

The Cricut Rotating Blade is crafted to cut the cloth. It uses a 12mm rotating blade tip (it's like a small pizza cutter) to hack its way into products without trailing. This ensures that you can slit the unbound cloth when using this cutter.

5. Knife Blade

The Knife Blade of the Cricut is specially designed to cut materials and cut much thicker and heavier materials than any other machines. It's normally the same as a super ACTO knife or Cricut Maker

4.4 Extra Accessories Other Than the Basic Ones

1. Easy-press

The key materials to be used on fabrics. For adding vinyl fabric, the Easy-Press is the awesome machine to do so. Results seem excellent while using on a flat surface. e.g., you might add custom plate decals. If you're feeling adventurous, you might also use it on the mugs. Overall, this is the perfect machine for clothes. It's going to heat up easily, and it's not going to take longer than 60 seconds. Everything is based on which machine you've bought. It's understood that the larger the machine, it consumes extra time. Moreover, with the latest Easy-Press functionality, you can heat up to 410°F

2. Foil Transfer Kit

Suppose you are using too old brand accessories. In that case, it may be potentially harmful to your machine (and causes to cancel your warranty), especially since these are built to work along with Cricut Maker. The kit named Foil Transfer includes:

- Single Foil Switch Housing Tool
- Foil Transition Tips 3—Fine and Normal.
- Tape

With this amazing gadget, you can add awesome foil accents to your designs, and it's super quick to do.

3. Bright Pads

The Cricut Bright Pad is a tool that is helpful during Lights up in Project. You might have used some light mats, too. They're beneficial when operating in darkened rooms (and at night) for projects with thin, hard-to-see bits. The Bright Pad will be used anywhere there is an electric socket having with a 6-foot electric because of this, you don't require a Cricut machine to use it! This is what you need to turn on the power and adjust the brightness level. There are 5 brightness settings, so you can conveniently adapt them to your designs.

4.5 How to Keep Your Cricut Maker Clean

Your machine may gather dust or paper pieces with time, use, or grease seen on the carriage track. Therefore, a cleaning machine is required.
Follow the given instructions when cleaning the machine:

- Always separate the unit from the power supply before cleaning.

- The unit itself may be washed with a glass cleaner poured on a warm, clean rag.

- If you notice that static electricity gives rise to dust or paper pieces, you should easily wipe it off with a clean, gentle cloth.

- When you see lubricant on the bar, the carriage passes around.
- You should use a cotton sheet, tissue, or gentle cloth to kindly remove it.

You Should Start as Follows

- Switch off the Cricut Explore machine
- Shift the Cut Smart cart by moving it gently to the other side.
- With the help of tissue paper, you may clean the Cut Smart, rubbing around it all.
- Move around the Cut Smart carriage towards, moving it gently to the right.
- Repeat the cleaning method of the Smart Tissue Carry Bar, rubbing across the whole bar.
- Shift the Split Smart cart steadily to the middle of the rig.
- Open the lubricating package and squeeze a less amount of grease at cotton swab

4.6 Never Use Any Scrapper for Cleaning

For cleaning the device, the mat must be clean as well. Materials that cut with the Knife blade's help will also be sources of more dust or particles that stick with the adhesive. For the long life of your Grip mat, you must follow the cleaning process below:

- Clean big debris from tweezers
- Should not scrape the mat. Scraping is going to drive substance debris deep into the adhesive.

Clean your mat as follows:

- Place your mat at the sink and remember that a hard and straight surface must support the mat flat.
- The mat must be cleaned with warm water. Using a hard-bristled plastic brush to softly scrub until the whole surface of the mat has been washed.
- Dry with a paper cloth.
- For the softness of the mat, let the mat air dry.

4.7 Avoid Touching Your Mats with Your Hands

The existing adhesive tape is frailer than the others. Fingertips will easily break the adhesive tape in the mat, which causes it to lose its grip. Only be patient with your mat and aim not to hit the adhesive whenever you do so. You may use a brayer to support your adhesive tape on the cloth to your mat if it helps (don't push it firmly, enough to stick the cloth to the mat). Using tweezers to pick up the parts from the mat to secure your adhesive tape from your finger. Don't even try to pick loose threads from the mat—if you want to pick these, just use the tweezers for this.

4.8 Threads On the Mat Don't Matter

Grains are existing in the fabrics. This means towards the woven woods, which runs with the selvage edges of the cloth.

Design Space app helps regarding fabric placement so that the grains may be going in an accurate direction. On the mat overview, if the amount on the piece is correct, set the cloth on the mat, so the grain easily runs on the entire mat. If the amount is on its side, set the fabric correctly at the mat so that the grains run left and right on the entire mat. When you have finished the cuttings process, then please follow the mentioned below instructions:

- When Cutting is finished, it is recommended to remove the extra fabric first.

- Don't touch the adhesive tape during removing the cuts; make your hand dry for adhesive tape stickiness.

For removing the cuts from the mat, Broad Tip Tweezers will be a great tool.

For Fabrics, a spatula will be used for removing cuts. They may clump when you try to remove them, but a prompt passing along with an iron will make them straight.

4.9 Transfer Tape

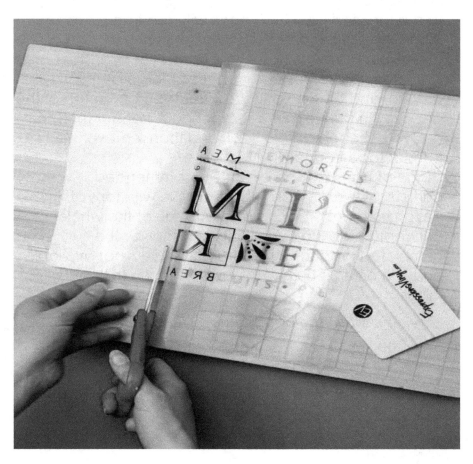

The transfer tape is not a tape, practically. It's just an adhesive material that helps you move your design towards your finished project, and the Transfer Tape provides in the shape of rolls and sheets. While the scale, design, and tackiness can differ, they both work the same: transfer your vinyl decals towards the final project! Keep in mind that the first thing that you must cut out is your vinyl trickiness pattern, and the Silhouette blade always makes it possible to cut into the vinyl (don't cut into the back!), or you'll have a tough time attempting to pull the vinyl out of the back with the transfer tape. When the cutting process of design is finished, and all the excess bits are cut out, it's time to use your transfer tape. Break the transfer tape part that's as large as the vinyl pattern, and then hold the transfer tape at the top of the decal. With the help of a scraper pad, transfer the tape below to the top of said vinyl, and then remove the transfer tape from a vinyl template.

Usage of Transfer tape is highly recommended, particularly if a vinyl decal is available with tons of tiny design elements, making it easy to select the whole concept and bring everything together for the completed product. And if transfer tape is not available and you are in a hurry, you should use the following things:

- The tape used by painters.

- The tape known as scotch.

- Transparent type Contact Paper.

4.10 Tips for Felt

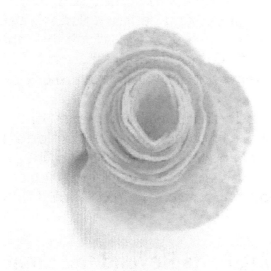

Felt is a common material that Cricut users want to cut...
and the second you place it on the mat, you notice it
can be tough! Usually, you cut three separate styles of
felt by using two separate Cricut blades, the first one is a
fine point blade along with the Cricut Explore machine,
and the second one is Rotary Blade along with the Cricut
Creator.

Pros: Cricut Felt machine cuts the best out of three felts.
There is only a feeling that almost fully sliced through your
Fine Point Blade on your Explore. It doesn't drop a bunch
of lint on a mat, either. It comes on a scale of 12×12,
ideal for the cutting of your Cricut Machine.

Cons: The Cricut feeling is not exactly fluffy and luxurious. It's rigid, and it folds ugly instead of folding beautifully. It doesn't... sound like it's thought. And it will come only in a couple of colors—only with combo sets, therefore, if you like an extra sheet of a certain color. Price per sheet is a costly item. Since it's so small, I don't think the flowers are beautiful as the other styles of felt, and this is the mixture of the felt wool and the felt of the Cricut machine:

The Rotating Blade comes with the Maker, and slices felt like a pizza knife, rather than running the blade over the felt to slit it. I think this fits a lot instead of a fine point razor. Here's how it was cutting, utilizing a felt material framework. You'll need to open "Edit Tools."

4.11 Pushing Mats Beyond the Limits

Cricut pink mat is rare, and if you're attempting to do a lot of difficult cutting with the help of a rotating blade, you might find that the mat already continues to peel. The rotating blade is not to cut a smaller circle than 3/4". If you cut smaller with this than that, I guess you must build more pressure on the said blade and pad, and it's not built to deal that type of pressure, and you will start your mat peel.

4.12 Do Not Attempt to Re-Stick the Mats

A huge number of videos are on the internet about re-sticking the Cricut mats. Said tutorials including water, baby wipes, and tissues, GooGone spray and adhesive tape, and much more stuff. Like said before, the pink color mat adhesive tape is entirely different than the other adhesive tapes on the mats. The adhesive tape on the pink mat intended to hold the said fabric and loosen it quickly. If you ever find a method to re-stick this mat, you will surely come back and edit this article. It's an easier way to take care of the mat using the advice above than repairing a fully ruined mat.

And if you've been stressed to keep your mat neat and clean, these tips will be profitable. If you have something to say, please let us know in your comments, and we will update this article.

Chapter 5: How to Use Cricut Maker's Software in the Design Space

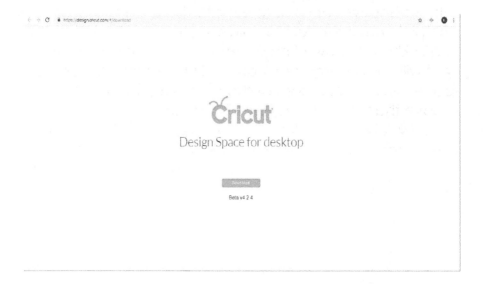

This chapter will instruct users on utilizing Cricut Design Space for the Cricut if users have been curious how to utilize this application. This chapter would describe, together with techniques and suggestions, the fundamentals of the software that will help one to make great creations with the Cricut device.

5.1 How to Access Cricut Design Space?

1. Open a tab on the internet and then head to design.Cricut.com

2. Select Search. During the update, the display will shift. This is going to be a bit distinct with any browser. In this scenario, Google Chrome is preferred.

3. Double-tap the document in the window or in that Downloads section whenever the download is finished.

4. Choose the options to accept the app's agreement if the window unlocks to inquire if users trust the app. A setup window displays the installation progress

5. A configuration window shows the progress of the installation

Beta v4.2.4

6. Log in with the Username and password for Cricut.

7. Users immediately add the Design Space icon on the Desktop of your computer's screen; you should right-click the button, pick Add to Taskbar, or move the Taskbar button to conveniently add the shortcut.

8. Experience utilizing Design Space on your Computer!

5.2 Cricut Software Primary Menu

The Design Space manages designs with features from Design Space's major windows, such as Home and the Canvas. One may also access all those other Design Space functionalities, such as the Print and Cut Adjustment, Custom Material Planning, Account Information, Connect Cartridges, Parameters, and Support.

When users start Cricut Design Space, it is that first display users can see.

At the extreme top left, one will notice three lines (it is a menu) preceded by "Home," "Welcome, [[Name]]," and afterward "Projects."

After that, the drop-down list is available to pick the Cricut machine's variant (either Cricut maker or Explore), and finally, the "New Project" key.

Cricut advertisements are on the upper edge of the home monitor, preceded by My Creations (all the save designs), Cricut Access (creations that users can order would include with the Cricut Access affiliation), My Prepared Projects (projects produced by experienced designers), Latest Video Guides and then some rows of suggestions for seasonal projects.

Let's view the upper left corner of the "Three Lines" on the Main menu.

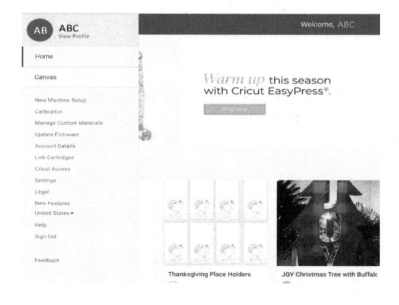

Home

It brings one straight to the tab of home display

Canvas

Bring users to the canvas, the core portion of the Design Space that end users will utilize. A bit farther down, one will notice all the information regarding the Canvas. The Cricut workshop is to create things, one will notice a variety of that kind of screen here!
It includes a wide gridded workspace with features at the edge, the guide at the left, and a Layers and the Color Synchronization Palettes also at the right.

Setup a Latest Device

If users have the recent Cricut Explore, the Cricut Easy Press Two, or Cricut Maker, it is the spot to set everything up, register that, or upgrade it.

The Calibration

For the Rotary Knife (Cricut Maker), the Knife Blade (a Cricut Device), and then Print & Cut, users can see calibration choices.

Custom Supplies Management

Here users can notice all of the materials adjustments they have attached to the device. The Term, Cutting Pressure, Multi-Cut, and Knife Style parameters may be adjusted for each content. One may even select a new content if they click the whole route to the lower end of this section. People would just not consider adjusting such settings until users are exactly sure of what they are doing.

Firmware Upgrade

It is where users go to upgrade their firmware for a wired device that they have. Checking it from period to period is a smart thing.

Information of Accounts

This would be where users may obtain information about the account, such as ordering history, transaction setups, and membership data.

Cartridges Connection

People could connect them up in this if they have some Cricut cartridges. Only on a computer or laptop device could anyone do it.

Accessing Cricut

Users may log in to Cricut Access or track the subscription online. Those who signed up for all this recently could tell it is probably worth everything! It would be much better than shopping a la carte for particular items, plus there are several pictures, styles, and designs from which to choose.

Configurations

One may adjust the Design Space framework settings and move the measuring units among Imperial and Metric.

New Features

This is where users could figure out more about the latest functionality. When they click on a certain button, nothing occurs, so they are not confident about what is happening on with it.

Country

Users may adjust the location here. Choices like Australia, the United States of America, and the United Kingdom

Support

This will direct users to the Support Hub, where they will find FAQs, tutorials, fault detection, and much more.

Logging Out

There, one may sign up for the Design Space status.

Feedback

Tapping here will open up the form where users can share feedback and recommendations. Now that users have just explored the menu in-depth, it is time to run over a few of the helpful features of a Design Space, they will mainly utilize these application resources in the various projects, so it was a great idea to examine them in such detail and understand how to employ them

5.3 How to Employ the "Weld" Feature

What Would Weld Indicate?

The welding method helps one merge shapes to make a new design by cutting any contrasting cut lines. Users might have two different photos, and they only want it to become one they would weld! And maybe one has got several script codes, and they need all the characters to be joined together—which is where they would need the weld.

Welding a Text

When users compose text in Design Space, occasionally, writing doesn't seem like they want to, or maybe they need to customize where the characters are.

Imagine they wrote "Hello" in the Design Space and selected a cursive script. That is just what it worked out to be.

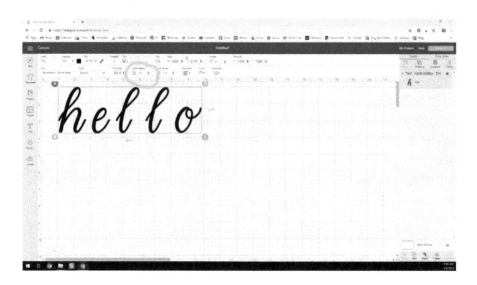

The characters are all isolated. In the project, they don't need them to appear like this, though, so they need to solder them together to be one fluid term, and everything has been linked. There are two forms this can be done. Users have to press on the texts first so that they can be illuminated. When there appears a sky blue rectangle across the text, they will realize they have it picked. Then, glance at the edge of the page to view where it says "Letter Slot." For the characters to come nearer together, they can reduce the spacing. If users choose to expand the gap between letters, they should use this option as well. Only before the characters led to where they needed them to be, they just continued pressing down.

Users would need to unbundle the text to accomplish this. Once again, pick the text such that a blue box exists again surrounding it. Tap on "Ungroup" in the upper right corner below "Layers" after they have picked this.

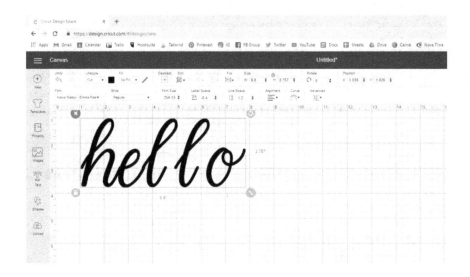

All the characters would be scattered and on their own when they have un-grouped them. One after the other, a user would possibly want to carry them.

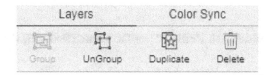

- Users are now attempting to gradually shift the characters such that they connect moderately, to be worthy of being welded together. All of the characters are also separately isolated, as one could tell from that layer panel on a right hand. They ought to illustrate and re-group most of the characters.

- Much like they have ungrouped characters, they continue to re-group them, following the same pattern. By tapping on one after the other or by tapping all at once, showcase all the characters so that these are all

wrapped in a sky blue triangle; after this, press "Group" on an upper right side of a panel in that layer display.

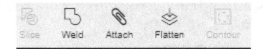

- There they almost are! When they have been gathered together, press the weld button at the lower right of the desktop. Then it will appear like that until they are completed:

That was it... so they have effectively welded the script/text together!

5.4 How to Utilize the Feature "Slice"

In Cricut Design Space, a Slice feature is an alternative that helps users to divide and cut out two adjacent photos or layers to create an entirely new layout. This app is great and, by all means, one of the favorites, since users can modify and make new custom patterns with current forms and photographs with this.
A Slice feature has been at the Layers board's base and works when they pick just two layers. They did not split more than three layers, so the software doesn't realize what form to trim against each other. One should not be discouraged anyway; after that mini-tutorial, they will teach everyone a technique to slice some photos. Now, let us look at how Slice is functioning at a moment.

- Drop a square and a heart on the Canvas Area by clicking on the Shapes button located on the left panel. Check out the following graphic, and let's have a little chat about what I did.

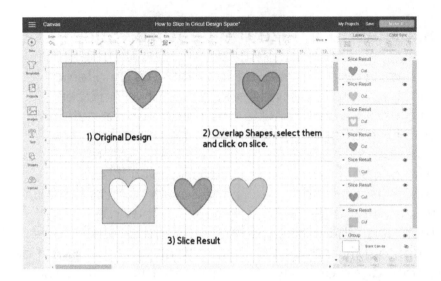

1) Original Design

2) Overlap Shapes, select them and click on slice.

3) Slice Result

- Remove a square and the heart on a canvas field by tapping on the Shapes icon's leftmost section. Look out for a preceding graphic and allow to have the little talk about what they accomplished.

- Were that square and a core correct for the initial prototypes? They decided, though, to take a heart out from the square, which sounds scary, it's not.

- Put the heart on the upper end of the rectangle, pick all layers, and press the Slice key to do all this.

- Users would only have three separate layers after chopping.

- They chose to "slice" out from the wider form, the glittery heart in this situation.

- A clone of the form decided to "slice" the purple heart in that situation.

- And finally but not all, a fresh template with a cutting out of a picture against which users utilized to "slice," as well as the

purpose they sliced in that first spot, a sky blue square in this scenario.

5.5 How to Utilize the Feature "Flatten"

There is only a simple aim of the Cricut Flatten feature: to flatten multiple layered photos (or several layers of only layer photos) into the standard printable layer. The Print and Cut function can be used. That's how this feature can be used:

- Launch by opening a Cricut Design Space practice document.

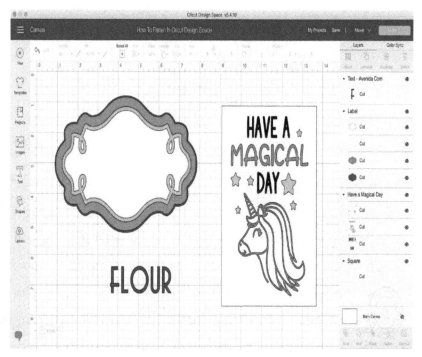

- There are two separate collections of photos and scripts for practice in this practice document, so users are indeed only

supposed to utilize the mark and "flour" script for the initial lesson, so cover the "Having a wonderful day" and plain squares layers. Assume if they are creating pantry tags and need to print these on printable stamp stock, then have the Cricut cut and create a pantry tag sticker on the outside of its label form.

- Pick the term "flour" and move it to either top or a form of the mark.

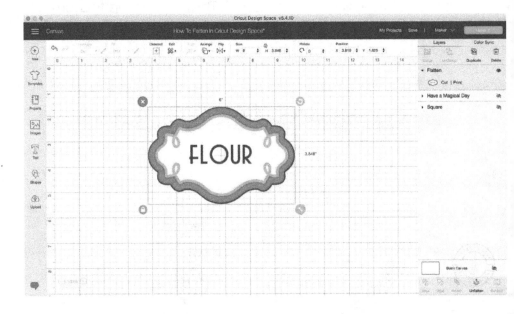

- Pick both the mark and the term combined first to flatten.
- To choose all layers, users can press and move a square across the whole mark, or they could choose one picture, then keep Shift on the keyboard when choosing the other photo. In that Layers board, one could also choose one layer, therefore keep Shift on the keyboard when that other layer is clicked.

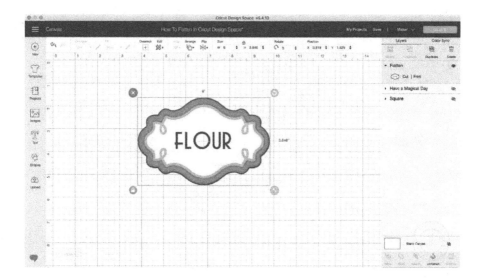

- Select your marks and then combined terms to flatten them first. You may press and then move a square over the entire mark to select all layers or select one photo, now hold Shift on the keyboard while selecting the other photos. You can also select one layer shown on the layer board. Hence keep the Shift on the keyboard in case other layers are clicked.

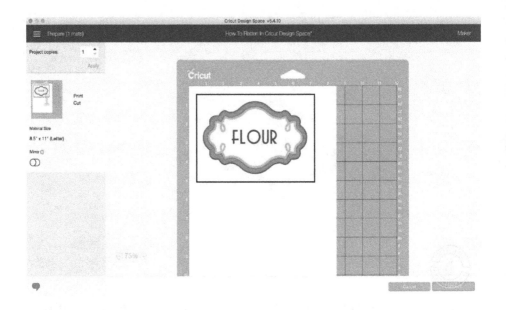

When users press Flatten, those layers are all coupled into the common print, so a "Flatten" layer is sliced, and all those inner cut lines are deleted (View how there were not those black lines along the outer side of the word "flour" as well as the yellow edge of the tag).

5.6 How to Utilize the Feature "Attach"

Users could lock photos and script in the spot with the Connect tool such that positioning of the forms on the slicing mat retains the very identical spacing that they notice on a Cricut Design Space display panel. Otherwise, Design Space switches to "paper saving mode" and changes the design instantly. It also helps one connect a typing layer or rating layer to the slicing layer, ensuring they could rate or sketch on a substance on the computer AND slice out a form. Everything in one move.

- Begin by launching the Cricut Design Space practice document.

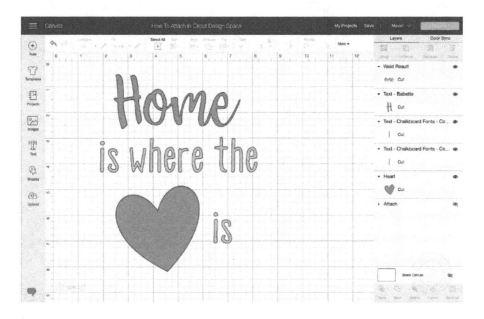

- In the final project, Users have already put the script and heart form where they like them. Choose all of the teal photos first to utilize the Attach feature: the term "home" as well as the heart. The characters "ome" have already been welded into a single picture; however, the "H" would still be a single layer. To pick all layers, they could click and move the square across the whole phrase, or they could choose one photo, then holding Shift on the keyboard when choosing some other two photos to choose both of them simultaneously. In the Layers section, one could also choose one layer, then keep Shift on the keyboard when the remaining layers are clicked.

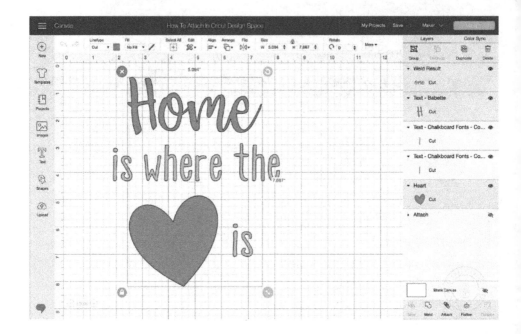

- The Attach feature at the Layers grid base should trigger when they have picked all three magenta layers (it would be black and tapped instead of grey). To connect the chosen layers, press "Attach."

- When users press Attach, all layers have been "fastened" down to an underside layer, and then all layers are "clumped" together in an "Attach" file on the right-hand side of a Layers panel. These images for themselves were not altered at all in the whole example; however, all three layers were switched to an "Attach file" in a Layers board. If the classic layers were various shades, they would become a shade of a lower layer once connected. Now choose the two font layers in orange and tap Attach once more.

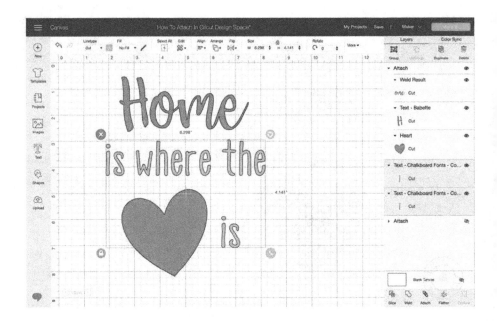

- Users also have a second "Attach document" in a Layers board and still the same as every other singular pattern layer users could even start moving each document around rather than operate with them as users like. And so now, if users press the green "Make It" icon, they will view that on a Develop screen, spacing that users organized on that Canvas display are conserved.

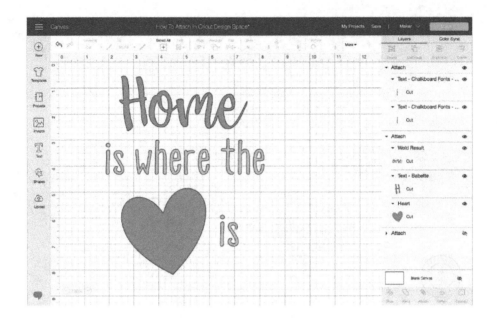

- A yellow text setup seems to be the exact as it would on a Canvas display, and if users glance at a teal thumbnail on the left, they would perceive that "Home" and a heart on its slicing mat were, therefore, secured in place.

5.7 How to Utilize a Feature Called "Group and the Ungroup"

If users know how to cluster and ungroup writings, one could insert a nice texture to the projects with Cricut. Here are all the directions for utilizing these features that users can implement.

- Begin by opening a new file in Cricut Design Space software and get access to the canvas. When you're on the options, click "Text" to submit your preferred text.

- Select the font, layout, and size after composing the text out.

- Ungroup content now by tapping "Ungroup" in a segment of layers.

- As users could even view in a panel layer, all of the characters are separated from each other already. Users could still relocate the characters separately as per the spacing that the user would like.

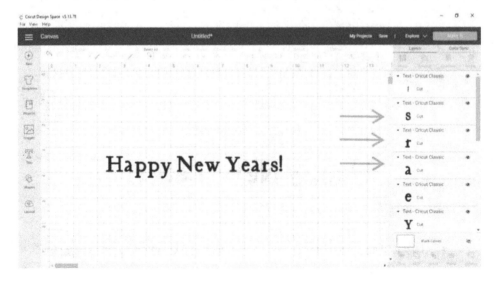

- If users just want to reduce the area between the words "current" and "year," the end-user would then group those words rather than shifting each specific letter. To do that and showcase over the script, users need to group and click "Group" in a Layers grid. Do the whole step for other phrases again. Rather than highlighting the characters, users could also press the letters on the layer segment.

- Now that all these words are separately grouped, the term could now be shifted to reduce room. Users could do it by relocating the pointer or arrow buttons on the keyboard to enhance or reduce the area using an "X" and "Y" location on a toolbar.

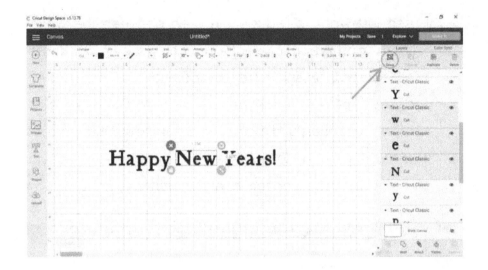

- The above group and ungroup function could also alter a few of the words' shade. By trying to access the shade panel, a shade could be altered.

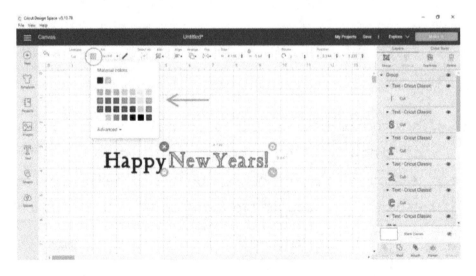

5.8 How to Utilize the Feature "Duplicate/Delete"

Duplicate

Any layers or prototypes users chose on a Layers grid, or canvas region would be reproduced by such a choice; this would be quite useful because users would not have to reconstruct the layout from root to tip. It is indeed copied and pasted like that.

Delete

This option will remove any of the aspects that users chose from the canvas area or layer segment.

5.9 How to Utilize a Feature Called "Sync Shade"

This tends to synchronize the shades in the project very much simpler, so users know they will have to cut on the identical stuff. In the right section, users just need to launch the Colored Sync panel and pull and drop every other pattern into another layer users need to synchronize with. If the user needs to split out almost all the Chartreuse stars, they slide several other stars in a Color Sync segment to a certain layer.

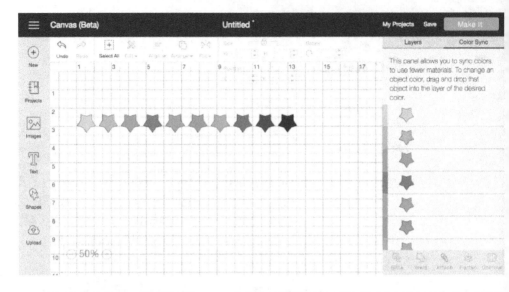

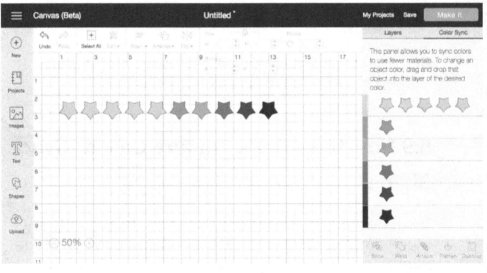

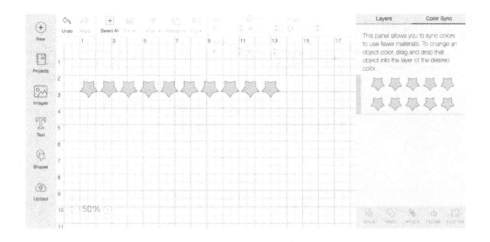

5.10 How to Utilize "Menu Text"

Just like the name implies, these methods are essentially designed to inject text into the projects.
If the user picks Text from the left list, the Text list shows at the peak of the primary menu.

One would also notice font choices in a Design Space underneath the script menu, much like every other word processor program. Press the Down Arrow button here, and a font list should appear.

Fonts

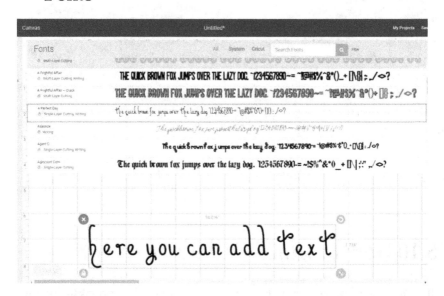

"All" (Machine and Cricut fonts), "System" (Ones computer's system fonts), and "Cricut" may be ordered (already paid and free scripts accessible on Design Space. If one had Cricut Access, many of them would be in the membership).

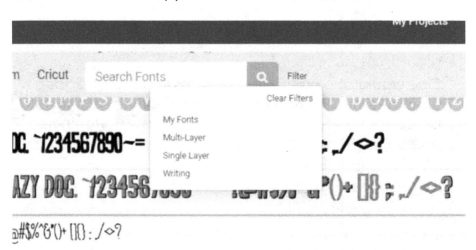

One could type it now and check by title if they recognize the script's title that they are searching for. They would filter My Fonts (the above involves the device fonts and, if they are also a part of Cricut Control, the membership scripts), Multi-Layer (font styles with more than a layer to trimmed), Singular Layer (fonts with quite the single layer to slice) and Composing (fonts with the singular layer to split) (fonts which are a single line and would function with Cricut Markers or that Debossing or Engraving tool).

To pick a text type, press the Lower Arrow there. One should view only a couple of such choices, based on the font they have chosen.

Linetype		Fill		Deselect	Edit		Arrang
Cut	▼	■ No Fill	▼ /	+			

Font		Style		Font Size		Letter Space	
A Perfect Day	▼	Regular	▼	72		VA 1.2	

A - Regular

B - Bold

I - Italic

B *I* - Bold Italic

A - Writing

Styles of Font

- Regular: The default edition
- Bold: Thicker form
- The Italic: Sloped edition
- The Bold Italic: Denser and sloped edition

- Writing: This is a single text, and it can be perfect for your Cricut Pens or the Engraving Tips. You may use the Debossing Tips as well.
- Write in Italic: Slanting variant of a single line (these are good for the Cricut Pens. Also works well with Engraving Tips and the Debossing Tips)

Size of the Font

Another possibility: by pressing and moving the colored double-sided arrows at the base right of a script box, it may also alter the size.

Line Space

The amount of space among the lines of the script could be changed here.

Another choice: Users could even activate text lines if they could not get this exactly perfect, then they could pull them where they want.

Letter Spacing

Alter the amount of space the letters have between them.

Another choice: they could also activate the characters and move them where they like them if they could not quite have it correct.

Alignment

To adjust the text orientation to Left, Middle, or Center, press the Down Arrow there.

Curve

Using this method to curl up, downward, or inside a loop of text. Pull the lever to the left: all ends of a document are bent upwards.

Push the lever towards the right: all ends of the document would be bent downwards

Even in a box, they could insert a particular number. Negative figures point the ends upwards, and the sides downwards are angled by positive figures
Important: If the user moves the lever to the right or left, it would produce a text loop.

Special Characters

- Begin by attaching some standard text to a canvas to access unique font letters in Cricut Design Space. Note: They must utilize a font with unique letters or glyphs, such as that of a Fonts script, which they only give free with the license for consumer use.

- Then bring up the desktop "character chart." They should place this in the search field of the desktop to quickly locate it.

- From the drop-down, choose the font you like. Then, to view the specific letters and glyphs, search the "advanced version." Users will view another box light up.

- Swipe and press until you view "Private Usage Characters." In that character chart, they could then display the unique characters. Tap on just one that users would just prefer to utilize.

- Paste it across the letter that users would like to substitute in the Design Space. Mention: This would also show up in one's text formatting window as the box, but on the canvas, this would look great. When users are pleased with it, proceed to change the text, and the template is prepared to split!

5.11 How to Utilize the Feature "Stencil" In A Design Space

It has been a great improvement to the sewing room to get a Cricut device for some projects they might draw up. They could render reused stencils and one-time stencils. Only adopt these measures to create a stencil including Desing Space:

- Press the Insert Photos button and type "heart" in the search box. Within the program, this should bring up in most of the heart photos. Showcase the picture that better fits users and press Insert Photo

- Pull the core to the appropriate size. To insert font from the left list, press the Add Text icon and then type. To alter the font, press the Edit button on the right-hand menu for all scripts, and then choose the font users desire. Change the text size to accommodate within the heart.

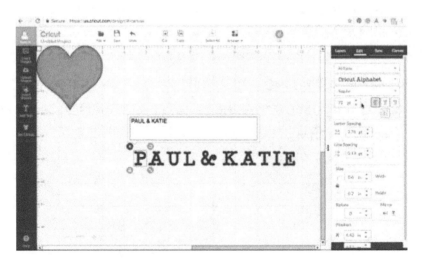

- After that, maybe you also want the picture and the text combined, but they have an empty area where even the script is. To perform that on the right list, press on Layers. Tap on Slice and show the core and a paragraph of the script. Since there are two text lines in one heart, repeat choosing the heart once more, choosing the second line of phrase, and tapping Slice. Users could transfer the heart when viewing that the script already holds blank space in the heart's picture. Remove each text box that is not required anymore.

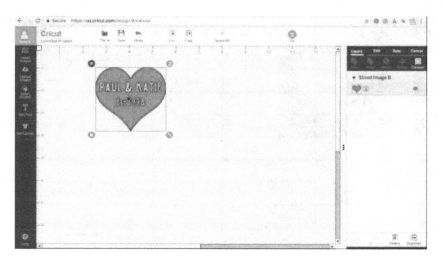

- Users seem to be near, but they are not yet finished. After they have utilized their stencil, this seems to be what they want one completed photo to appear like, so they need to develop a false view. From either the left-hand menu, press Select Shape and afterward choose Square. Users need a bigger square than the picture, so pull it down to the size users need. Drag the photo over all the square afterward.

Tap Organize from the upper menu and choose Shift Forward if the photo attempts to conceal underneath a square.

- Steps were repeated above for Slice. Pick the two icons from a Layers panel on the right-hand side and press on Slice. Users would also view when they drag a square away that they are left with an optimistic and a pessimistic prototype. The stencil seems to be the negative one.

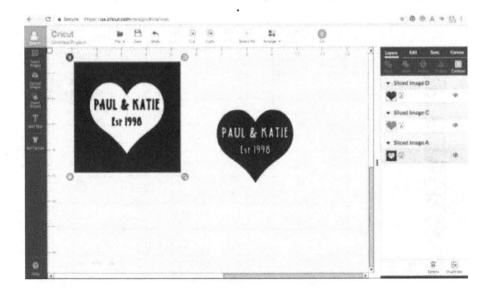

- Tap on the square green key that suggests going over to the upper menu to slice the stencil, and obey the stages to split out the stencil!

5.12 How to Utilize the Feature "Outline" In the Design Space

- Through Cricut Design Space, begin by typing the term and altering the font, and creating it quite huge so that users could indeed easily do that. If required, users could indeed resize it eventually.

- Utilize text equipment to shift the characters, to intersect if the font is indeed a script text with intersecting pieces.

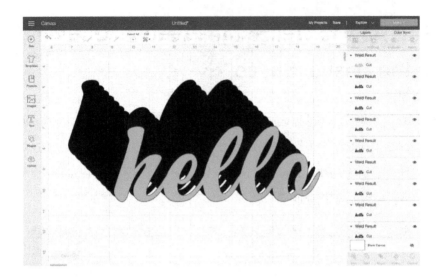

- To make the entire word one-piece, choose the word and tap Weld on the lower right. Next, make many duplicates of the word (12 or even more). Once users have the copies, at the upper edge of a Layers Panel, on the right, pick the top word and alter the shade. This would be the word, and the copies create an outline.

- Shift the word and all the versions of the outline apart so users could independently focus on them. Then it was time for the outline to be developed. Pick one of the black versions and place the word offset behind all this.

- For the next duplicate, then perform the exact but counter it in another extreme. Until they have a basic description, begin to layer versions of a term behind the primary phrase. One should then utilize the method for designs to quickly smooth the margins of the design. For instance, to aid smooth things out, they used a few ovals on tails of an "o".

They used them on both the highest point of the "h" and the edge of the "ls" as well.

- When you press a tiny lock to open the proportions, do not overlook that you could extend shapes. The oval often becomes better than the circle, while a rectangular is so often better than a cube. Often, zooming in improves. Moving the painted word out of a Layer until users are also satisfied with the outlines, choosing all the outlines layers, and pressing weld in the lower left to render them a single item.

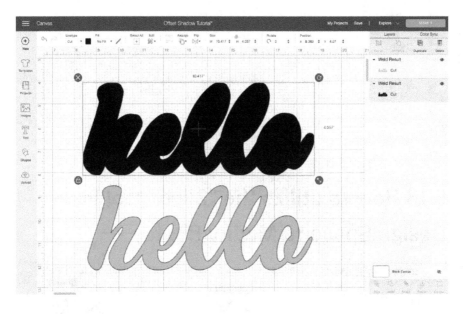

- Then, hopefully, to view the final project put the word more over the outline!

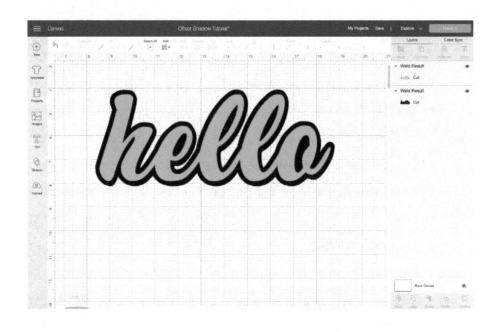

5.13 How to utilize the "Slice" tool in Design Space to Modify Photos

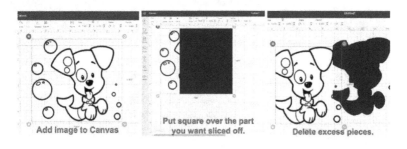

Add Image to Canvas

Put square over the part you want sliced off.

Delete excess pieces.

- Tap the picture and then press Attach Photos to connect the uploaded photo to the canvas in Cricut Design Space. Users have the choice of introducing to the canvas more than one photo at the time.

- Create the thumbnail a little larger so that by tapping on the correct lower edge and moving it down a bit, you can operate on it. Only far sufficient for them to view things clearer.

- A user would like to get rid of a dog in the photo they uploaded. Users did not view any canvas delete choices, so they will utilize the Slice feature for trimming the pet out. In the left-hand tool chest, tap Shapes, and then tap Square.

- Tapping on a lower left square far below the rectangle opens the square. Notice the lock symbol? Just press it. You can now switch the square by utilizing the proper lower circle in whatever form you choose. The user held a square over all the section they would mean to delete, the puppy.

- Press or highlight the square; click and hang the shift key on the keyboard. Clicking the bubble icon with the cursor, yeah, bubble to them. This illustrates all of them.

- Select the Slice feature in the lower right-hand corner with both the circle and the thumbnail illuminated.

- Begin taking the parts of the Slice down. Three parts need to be there. They could be removed.

- Commence this method before you edit the photo the way you want.

- This is how a Slice function helps users modify photos in Cricut Design Space.

Chapter 6: The Projects You Can Easily Make with Your Cricut Maker

This chapter enlisted simple newcomers' projects to learn more about the Cricut device and the Design Space and develop expertise with the Cricut creator to develop advanced art creations. They should register for any available SVG library to function with the creations below so that they could access pre-made templates from them

1. Magnets Making with Cricut

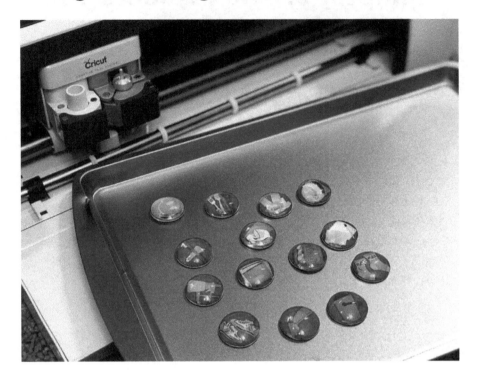

Materials Required:

- Blade Deep Cuts
- The Strong Grip Slicing Mat (purple)
- The Printer
- Smooth glass pebbles
- Blade Deep Cuts
- Simple Glue adhesive
- Glue Magnet Paper
- The Printable paper stickers

Steps:

1. Access the Design Space and build whatever they need the magnet should become. Those who first identified the photos they needed in Design Space for all these chore chart versions and then put the circles beyond them. They bound the photos together to scale them to the correct size (this was 1" for glass magnets).
2. Click everything and click Flatten after they have set all the measurements, modified background shades, etc.
3. Ensure that all photos have been altered from edit to printing and trim in the layer grid (the tiny printer)
4. Reorganize the photos on a mat to consume as little stickers' paper as necessary. Click Create it.
5. Loading the document on the sticker onto the printer and afterward click the print icon.
6. Users will now tape the adhesive paper to a magnet paper once you've written. There should be a sticky hand to both the adhesive paper and the magnet sheet, so they could do anything they think is easier.
7. Shift content to the magnet paper in Design Space (two choices that one would be nearest to the thickness) and place the magnet paper on a cutting mat with Firm Grip (purple). Please ensure the deeper cut blade is in location.
8. Click to cause the magnets to be cut.
9. Fix the imaging magnet to the base of the bottle utilizing a transparent adhesive and let it dry.

2. Glass with Adhesive Vinyl

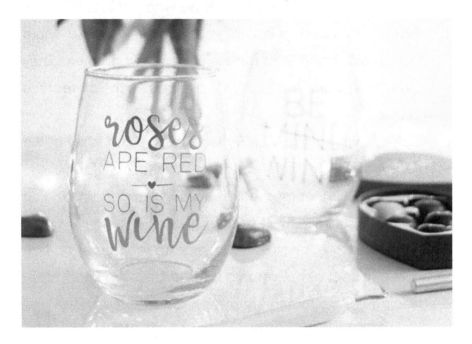

Materials Required:

- Glass Containers
- Vinyl glue
- Transfer Tape
- Cricut or even other devices for cutting
- SVG file (downloading required from the internet)

Steps:

1. Upload some SVG pantry tag files from the Web.
2. Import the data to Design Space Modeling Program.
3. One should utilize the "eye" in a Layers Grid in Design Space. The marks may show in Design Space. Mask the symbols

users do not want by utilizing the "eye" symbols in the Layers Row.

4. "Once they have only the tags that they want to see, tap at the peak of the Layers Section on "Ungroup.

5. Adjust the tags' height to match the jars by utilizing the upper Edit Toolbar's size feature. Those who rendered the tags between 2.5" and 4", so the containers were of the range of sizes.

6. Split the Cricut data, make sure to pick "Vinyl" as the form of content.

7. When the documents are split, the characters and the white circles filter out all except the marks.

8. Slice a slice of transfer tape that is the size of the mark sheet. Peel away the supporting paper and put that on the tip of the tags, adhesive end down. Rigorously force down.

9. Scrape the slicing mat off the plastic cover. Then slice each independent label across them so that they could add them to a container.

10. Scrape off the plastic backing, revealing the vinyl's sticky side. Set up the sticker in such a way that it isn't twisted, then click firmly. Try and pull off some bubbles

11. Scrape the transfer tape away. Push out certain bubbles that exist.

12. That's all! For those who love how labeled jars look on shelves, it would both be functional and elegant!

3. Oogie Boogie Bags for Treat

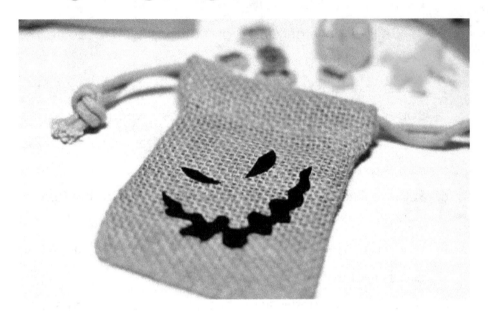

Materials Required:

- Burlap Favorite Bags
- Plastic Black Temperature Transfer (Iron On)
- The Treats/Goodies
- The Cricut Maker
- Heat Push or Easy Press

Steps:

1. Upload the FREE Oogie Boogie look from the Web by uploading the PNG picture document in Design Space
2. To suit the packs, adjust the Oogie Boogie mask (user made theirs 2" tall).
3. Redraw architecture before they get as many faces as packages do.

4. On the light touch cutting pad, mount heat transfer plastic top part down and submit it to carve.

5. Surplus vinyl from across faces and distinct faces from Weed (the necessary tool kit arrives in handy with that).

6. Preheat packs with burlap before tapping (either with the iron or the heat press for almost five seconds).

7. Via test and error, those who noticed that they require to push down onto burlap for longer to have the fiberglass to hold. They have learned that clicking for 35 seconds at 375° has it completely pressed.

8. Scrape the acrylic backrest from the left-hand corner steadily.

9. Using enjoyable snacks to fill the treat pockets.

4. Simple Felt Succulents with a Cricut Maker

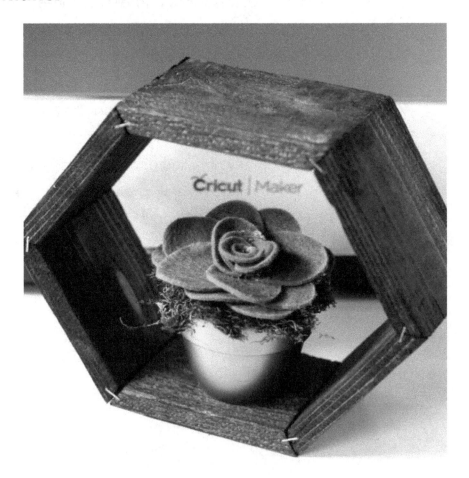

Materials Required:

- The Cricut Maker
- Pink Mat cloth
- Rotating Blade
- The Green Looked (8 1/2 X 11) •
- Blue sticker ink

- Ceramic Container (3 inches in diameter)
- Hot adhesive pistol and sticks glue
- Decorative grass

Steps:

1. There are fourteen oval forms created of the succulents. First, utilizing the Insert Shapes option, add a circle right into Design Space

2. Unleash and create the loop 1.5"x2".

3. Create fourteen copies of it.

4. Pick the size of the content.

5. For material, pick "felt."

6. Make sure that you have the rotary cutter in a tool slot. On the pink cloth mat, lock the felt, mount this into the printer and slice it out.

7. Pull the extra fabric back cautiously, and they would have beautiful felt ovals!

8. They are now able to gather a succulent. Next, stack together all of the parts and utilize the sticker pad all over the edges to ink.

9. Take an oval and place it in the center mark of adhesive and divide in half nearly all of the way. (Start leaving it slightly offset, see the image below).

10. To make a little rosette form, fold all edges in. You are going to glue three further oval parts in half as well.

11. Fasten the middle rosette with the folded oval.

12. Fasten the two leftover ovals until they have a form that looks like a small cabbage. This is the foundation of the leftover parts that they could even have to glue. They're not going to be folded in two. Only glue around the

center clockwise, positioning the leaves across each other to form a succulent form.

13. You will stick the moss into the small pot until the succulent is thoroughly glued and then stick the succulent to the tip of that moss. It's just that! It's already finished and now you have got the prettiest small succulent feeling to beautify the home

5. Mini Canvas Banner

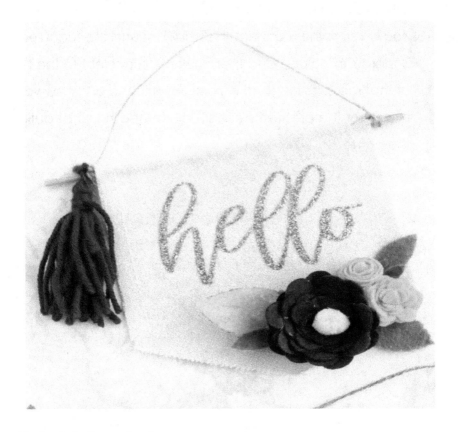

Materials Required:

- Easy SVG Web file slice (like the one in the above photo)
- The Cricut Maker
- Soft Grip Pad
- Iron-on Plastic
- Quick Press or the Iron
- Weeding Function
- The Felt
- Cloth Mat
- Mini Canvas Poster Banner (found at Michaels)

- Twine or String
- Dowel Bar or the Stick of a Small Popsicle
- Hot Adhesive Gun

Steps:

1. Upload the cut document for unlimited SVG. Using the Cricut to carve out the desired statement on iron-on polyester after users accessing the data. For such an iron-on project, do not even forget to pick "mirror split."

2. First, utilizing the Cricut weeding app, weed the sentence. Over the front of the tiny canvas flag, put the quote.

3. Using the latest Cricut Quick Press to stick to the canvas poster with the acrylic phrase. It certainly took a guess working out of iron-on projects for one to fall so in affection with the latest tool. It arrives with the cheat paper for thermal settings and a meter to help achieve the greatest results depending on the content they are considering with the project.

4. Properly remove the adhesive backing until you have applied the acrylic to the flag.

5. The enjoyable part arrives second. Build few other Cricut Design Space feeling butterflies. To construct many various felt roses, they utilized the Flower Superstore cartridge. Eve applies some extra adornments, such as ribbon, thread tassel, to the flag, free of charge.

6. Now it is time for the dowel bar to be attached to the rear of the poster. The rod slides inside, they made a tiny pocket and then used hot adhesive to lock it in a spot.

7. Utilize the twine or string to build the small poster hanger. On a couple of occasions, loop the rope around one end of a stick and bind the twine together to keep it in position. Remove the leftover piece then and replicate the same moves from the other location.

8. They have got it over there, a cute, easy, and cheap craft they could do in less than 15 minutes.

6. No Sewing Felt Nativity Finger Muppets

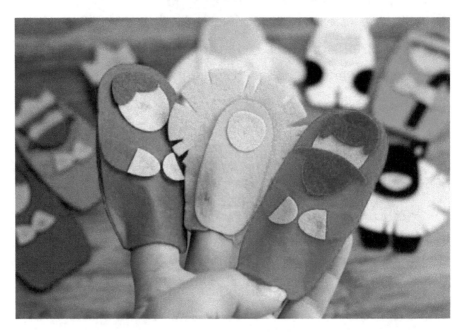

Materials Required:

- The Cricut Maker
- Rotary Knife (arrives with the Cricut Maker)
- The Sampler of Cricut Felt Skies
- The Carousel Sampler with Cricut Felt
- Cricut Fabric-Matte for Grip
- Warm adhesive gun and sticks of glue

Steps:

1. Start Cricut Design Space and select the file "Nativity Hand Puppets." If you don't have it, then Google search for it.
2. Tap on Make It and pick Felt as the material you need to slice. Pile the rotary knife into the machine and load the Cricut Cloth Grip Pad with the matching shade felt on a Design Panel.
3. When all of the mats have been cut out, gently group each one of those whole puppets along for assembling.
4. Create a line of adhesive across the rear of a finger puppet by utilizing the hot adhesive device. Place on the edge of the front part and click to lock. The other puppet parts, including hair, face, and limbs, are then glued together. Repeat for each marionette.
5. Mostly on the back section of a puppet, you could still create a finger form line of adhesive.
6. Now the marionettes are finished! Let all those tiny fingertips practice their favorite Nativity away.

7. No-Sew Reindeer Cushion

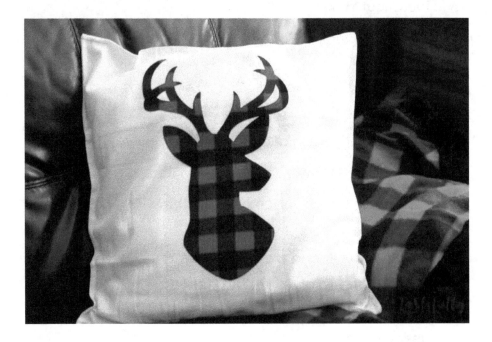

Materials Required:

- Buffalo Plaid Cloth
- Cushion Cover
- Cushion Patch
- Ultra-Keep Heat's 'Bond
- The Cricut Maker

Important: 12"x24" Pink Slicing Mat (they would pick a 12"x12" pink pad if users utilize a tinier cushion)

Steps:

1. By uploading the SVG document from the web and importing it to the Cricut application, open the design project, change the reindeer's size if desired.

TIP- Go to Prototypes and choose from around 100 multiple options, including cushions, clothes, doors, walls, flip flops, and much more, while trying to determine how large to build a picture!

2. Measure the additional couple inches, then cut a slice of Heat 'n' Bond. Fasten to the rear of the cloth with the sheet edge away from one cloth.

3. On the pink slicing mat cloth side up, connect the fabric with the Heat's Bond

4. Offer a prototype that would be trimmed. Please ensure they have the rotary knife on the Builder in a B clamp.

5. For around 5-10 secs, set the temperature of the cushion case with the Easy Press.

6. Put the reindeer on the cushion case and measure the center utilizing a ruler.

7. Adjust Easy Press to the reindeer at moderate pressure and implement it (300 ° for 30 seconds). You will have to do the move twice, once with the tip, once with the base, if a reindeer is bigger than 9"x9". Making sure you do it on a solid surface, like kitchen counters.

8. Swap over the cushion case and replicate the previous move. It is finished.

8. Shirt with Print

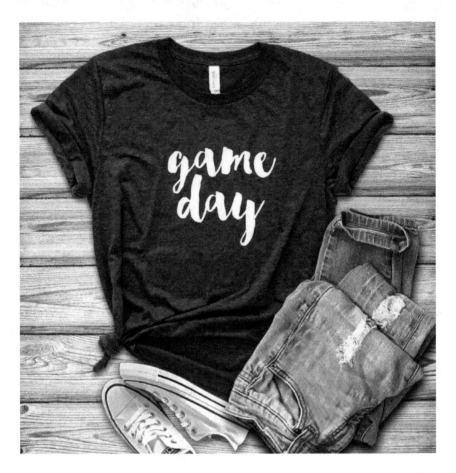

Materials Required:

- The Cricut
- Cricut Iron-On Plastic
- Kit for Cricut Method
- Easy Press from Cricut
- Bright Pad Cricut (it is optional but very helpful)
- Empty t-shirts and koozies

- Cricut cutting document and Bonjour Script for the shirt (can be found on the internet)

Steps:

1. Launch and change the split files to match the shirts. Transfer to a Cricut to remove; note to slice iron on a polished plastic face down in a mirror.

2. The weeing vinyl. The Bight Mat is really handy, the essential reading toolset!

3. Using the Easy-press on tops and koozies to mount the vinyl. They utilized Cricut iron on a protective coating for a cookie and squeezed them for thirty seconds at 360°. You should follow the same process for both sides, except on the inner side of the tops.

4. It is done!

9. Create a Bow of Hair with Cricut

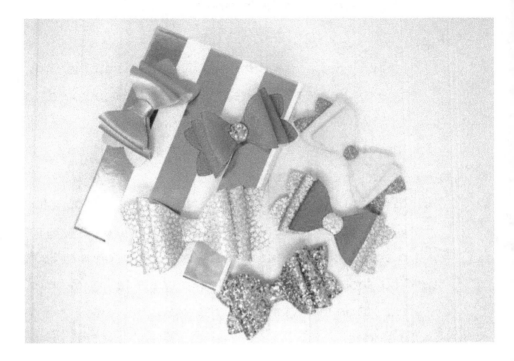

Materials Required:

- Hot Adhesive gun
- The Faux fur, leather, iron-on & felt could be used
- The Hair Clip
- The Cutters or Cutting Device

Steps:

1. Upload an SVG, or search for it on the web, to Cricut Design Space immediately. By accessing the picture in the bottom left-hand corner, you may resize the arrow. Depending on the look you aim to accomplish, you will create it broader or taller.

2. Change the scale as desired.

3. Break the outline out and draw an easy cleaning marker across that on the rear of a leather. To stop any sharp edges, carve out the pattern utilizing long, gradual snips.

4. Around the center of a bow, put a thin line of adhesive and fold that outer end into the base. Using the shorter bow, replicate this move.

5. In the wider bow center, put a tiny quantity of warm glue and put the smallest bow on the highest part of the wider bow. Just let it cool.

6. In the bottom layer, place a little circle of glue and place the bows on top, ensuring it is balanced. Wrap the whole bow across the center.

7. Using a hair clip and a little dot of warm glue to put the base of it under a flap. Push it tightly, then let it settle. Enjoy it.

10. Leather Ring for Napkin

Materials Required:

- The leather. You may use artificial Leather
- Cricut Maker with its Rotary Blade
- Button or Snaps
- Punch machine for Leather.

Steps:

1. First, consider the size you'll choose for cutting your towel rings; it depends on how large a cloth you use.
2. It is fine to produce a leather ring around 5.5-inches w x 1.5-inches h.
3. Now Upload any SVG file to the Design Space software.
4. One may load just 11 inches wide materials while cutting any dense materials you need to begin from far-right before loading your material.
5. Break off the leather with the heavy mats to make sure the leather doesn't move at all. Cut it off, then detach it from the pad.
6. Now it's pretty easy. Use a punch machine to make a hole on both sides of the leather. Finally, fold it and make a loop. Then pick and mount your napkins within a leather ring.
7. It's done.

Chapter 7: Tips and Tricks to Make Cricut Maker Easier and More Efficient

1. Set Your Machine's Dial at the Right Position

This may also be overwhelming as there are several content options on this dial. If you adjust the dial at Custom, then design software would mention potential materials and offers you the opportunity to choose the right material. From now on, you'll have more power over how your machine is cutting your idea.

2. Keep the Blades Sharp

Many artists never think to sharpen their blades and finally buy new blades! Well, many of us more rottenly buy trimmer blades. What should you do? Buying a simple tip from Cricut saves you a good amount of money and time!

Just Roll up tightly an aluminum foil ball, ensure that it's tight. Push the lever of your blade to stick out, but make sure not to fall out. Now stab your foil ball more than 50 times. This removes any debris and sharpens your blade as well. This can also be done for your trimmer-type blades as well.

3. Make You're Weeding Simple

In projects, Weeding is still a love-hate relationship.
We know many people who love to weave and go after
all the intricate patterns they might find. It is preferred
that you don't overload the projects with it!
Sometimes the little bits are hard to spot and are always
overlooked! It would help if you used a fine Cricut Tip to
see what you want to weed. Also, Sprinkle the pattern
with some talcum powder; after that, put it over a bright
pad, and then you can see the cuts easily, which makes
the process of weeding somehow easy for you.

4. Save Time by Using One Mat

You must position your materials over the single mat
even though if you want your project to be sliced
in various colors, just make sure that materials being used
are of the same type; you cannot mix different materials.
You can adjust the colors in the canvas so that they fall
over the same pad, or after pressing render them, you
can switch items to other mats, but it depends on the
project.

5. Print and Cut

When working with art crafts, never get upset with
printing and cutting projects. Keep the size inside the
Canvas Guidelines. It is always preferred to use an inkjet
printer to not transfer any heat over the paper. Just like
the Laser printer, which fuses the ink to the document
with heat, rendering it difficult for your Cricut
while reading the lines of identification that have been
produced.

To make things much simpler, print the identification lines on white paper instead of printing your whole project on your choice of color paper. Cut out some tape over the middle of the document to keep the identification marks at their proper place. The purpose is to make your Cricut identify the identification marks properly and then cut the pattern onto the colored document.

6. Keep Your Pens in Working Condition

You might have many Cricut pens and always want them to work well every time you need them. Just put your pens always upside down to allow the ink to flow even smoother. Nothing can be worse than attempting to use a certain color with your design, and at that time, you find that your pen is not working! By the way, fill the pens when placed at a 45^0 angle—it also creates a difference in how the ink runs smoothly.

7. Draw the Cut

Iron-on designs often have some weeding issues and matching problems to ensure all the concept parts mesh together. In case you cannot see the cutting lines properly and even do not like to apply the powder over the surface (it ruins the seal of your iron-on; hence it works like a lint of a project), use a fresh set of cutting lines, and change them for drawing the same lines along the top of your cut which makes it very simpler to see while correcting and weeding. Making sure you have a pen that does not mark your template while it is assembled.

8. Sealing the Deal

When making a design, stenciling is always something we like to do, and make sure that color doesn't see-through, you should consider a few choices. If you are working on wood, you can first seal the wood and then add the vinyl stencils over the wood. Even if the vinyl properly sticks over the wood, it will be leaked unless the bottom surface is not properly sealed. Just paint over the sealed surface. Please make sure that it does not leak through the seal. If you follow this, the results will be stunning and professional.

Chapter 8: The Best Alternatives to Design Space

You will need to build your designs when you have the Cricut machine in hand and you're using PC tools for those designs. The Cricut software at this stage comes into action. This one is the most common and realistic software used for creating these kinds of items. But unfortunately, it's still known as the costliest one—and maybe it doesn't have all the options you like.
That's why searching for an alternative Design Space is completely valid. It doesn't matter if you own a Cricut machine, still, you could find any of its alternatives which is more useful. Here is a list of information on these alternatives you can use for your projects

8.1 Sure Cuts

This is one of the most popular among other design software after Design Space. The popularity is because of its capability to work well with a wide range of Cricut devices. It works very well with Cricut standard and fully functional with the Silhouette as well. You may use it with Craft ROBO and Wish-blade, too, among many other devices.

Easy Operation

The first aspect you will find by using Sure Cuts software is the easy-to-use interface that it offers. In this software, you don't have to waste hours trying to work out how to utilize it—it renders the entire thing effortlessly.
This software offers several unique functions to its customers, enabling them to adjust color, control brush thickness, adjust stroke softness, and many more. You can also focus on your projects allowing more precise editing. And using the layer method, you're not going to have any trouble creating the most complicated designs.

Compatibility

This software runs fairly well on almost every machine. It has high compatibility with Desktop and Mac operating systems with complete support. You can work with over 30 different types of Cricut devices using this software—which is excellent.

8.2 Inkscape

Inkscape, another third-party software, is also an open-source application compared to the listed below.
This means you can have it for making designs too, and it'll offer all the functionalities at no cost. This ensures that you will get everything ranging from object creation and editings, such as painting, copying, layering,
or transformation, to rendering, importing/exporting files with full support. There is even a special vector route scheme, the power to build icons, maps, lines, text patterns, and even importing the most intricate works of art for editing and customizing.
It doesn't matter if it's open-source software, you should still expect outstanding assistance in any aspect, as well as lots of tutorials and guides to follow.

Powerful Editing Functionality

All editing tools which Inkscape offers are, in short, ultra-powerful. There's absolutely nothing you're going to find difficult to do while using this software. E.g., if you like to fill in any color, you can pick what you want flat, no matter if it is gradient or linear.

Import & Export Function

Another major benefit of using this
software is exporting and importing all files without any restrictions or problems. It can import and export files ranging from SVG, DXFs, PDF, EPS, PNG,
or OpenDocument, and the list continues—you
will get everything with Inkscape software.

Compatibility

Inkscape offers the greatest compatibility with the die-cutting interface program that is available in the design market. You will make the designs whether operating a Linux-based system, Windows computers, or even a MAC operating system without any issues.

8.3 Make the Cut

This is another good third-party program framework that you may use for editing the die-cutting designs. It provides the same functionality that Cricut Design Space does, varying from optimum design elements to excellent connectivity with most devices. Whether you edit shapes or make special patterns for incorporating thrilling effects in designs or even making the Cricut templates—Make the Cut provides them all.

However, the key value is the potential to function with a wide variety of files. So it not only gives its users a chance to get superb editing, but it will also provide unbeatable compatibility. Another benefit is how long this software stays in the market, making it a highly prestigious and secure choice.

Convenient Editing

Virtually there's no project you can't do using this software. You will enjoy free-hand painting, shadowing, auto-tracking, node editing, or even external fonts installation. There is also a jigsaw design framework available. It provides lattice design functions and the additional pre-set design elements that you may use if required.

Compatibility

Another advantage of this software is the opportunity to operate with virtually every die-cutting device available in the competitive market. You can use it with the Gazelle system, Roland system, Wish-blade system, Crafts ROBO, and others. Although it's not working with the Cricut machines, it's still one of the better choices you can find in the market. The greatest feature it provides is its ability to interact with a wide variety of files.

Fast Working and Well-Designed

In our list, this one is considered the fastest program. It works great if you want an app that works quickly and doesn't require many system resources—It can perform many functions required for cutting projects. On the other hand, you can also expect it to offer decent support, and it will have little or no bugs at all.

8.4 The Silhouette Studio

In our top software list, the Silhouette Studio comes in the
end to finish our collection. This is perhaps not exactly the
program designed to be used for die-cutting; instead,
it's a garment design and embroidery program. But still, it
functions as much as the already mentioned above.
What makes this software a good and outstanding app is
its strong editing and top-notch modeling functionality.
You can create templates with hundreds of layers,
and even larger ones can be made with even more
objects without noticing any difference.

File Integration

Users like software that can work with various files. Luckily
the Silhouette Studio offers this facility to its users.

Unique and Amazing Editing Tools

When you import any project in this software, you
will immediately notice the marvelous tools it provides.
Whether they are Sticky Notes, or Pop-Up Makers, which
make exclusive stamps for your designs, this software
provides Font Management, Wrapping, Tracing , and
even the amazing Glyphs system. In short, this
system offers you everything.

Compatible with Various Models of Machines

It doesn't make a difference which Circuiting device you're utilizing or the computer system you choose to connect with your Cricut device—Silhouette Studio can work with almost every model. It has compatibility with many operating systems, including the Windows operating system and Mac operating system. There's nothing to worry about compatibility issues.

Chapter 9: How You Can Do Business with the Help of a Cricut Machine

Although many artisans use their Cricut machine for pure pleasure and make crafts for their own homes and their loved ones, many others use the Cricut Device for business. Over the globe, so many people are working with Cricut machines and making money. With the use of the Internet, now it's simpler than ever before to get the goods out there to meet a massive audience— still, there are tons of ways to earn some money at a local level.

9.1 How You Can Make Money Using Your Cricut

- The most evident way to earn money from your Cricut is to build unique items for your clients. The Cricut will cut various things, and if you're making items for anyone, it may be a wonderful resource.
- Another way to make money from your Cricut device is by training the others. Stores such as Michaels have Cricut lessons and sometimes search for seasoned Cricut's to train.

- You may even offer local lessons in libraries, or you can even arrange them in your own house/office. Online teaching is another way to teach courses as well—you can set up your website or find a business that sells online lessons and lets you sell yours too.
- If you're smart at creating SVG files, then there's certainly a demand for that. You can build and sell SVGs on your page, Etsy and local groups, etc. If you're selling SVG data, then it may help you earn extra money easily.
- You may make money from blogging or YouTube channel. People are always searching for projects and directions— and these platforms have a massive audience for them.
- It takes some time to create a blog or a YouTube channel, but it can pay you a lot. In reality, these platforms possibly have the most ability to make a profit. When we claim that Cricut has changed our lives, that's what we talk about. Many of you probably know people who manage Facebook Pages, make money out of them, and have built online courses to offer them to other people striving for knowledge. There are many opportunities to earn money with your Cricut device if you're skilled and ready to practice!
- And frankly, even though the company isn't directly about Cricut, any other device can be used across various work lines.

What Will You Need to Take a Good Start?

Well, the very first thing that you need for taking a start is the Cricut machine!

Once you have it, the next thing you need is a good business plan—it will determine whether there is anything else you may need to invest in. Hence, if you're planning to make t-shirts, you're going to need the iron-on vinyl, some kind of infusible ink, etc., for white t-shirts. Suppose if you plan to do anything that involves iron-on/HTV, you're going to need some type of heat press machine. Some traditional heat press machines are available and can help build things in mass production— However, they may be cumbersome. In some cases, a Cricut Easy-Press machine is recommended. It has one model of every size. If you're not dealing with mass production, then this might help you.

If you want to create an SVG file, you're going to need some design software. It is recommended to have a good camera if you're planning to sell online so that people get visually attracted to your stuff. Learning photography skills along with learning how to make items look attractive can boost your business. If you're planning to make a blog or a YouTube channel, you will have various supplies with you. If you want someone to be inspired, you must have a good grip on your products and materials—you might not be in a position to get them all at once; hence it is recommended to set aside a certain portion of your money from your earnings to invest it back into your own business.

Finally, one of the greatest things you ever need for doing business is motivation. Many people are starting their businesses and then stop them, you know why? The biggest thing that is missing is motivation and their ability to push through their growing stage.

How Can You Search for Some Business?

Last but not least, a question that may come to your mind is how to get some business, right? If so, then there are various places to get business—all you need to get started is to have the motivation and hard work. Here are some of the most popular options through which you can make a good amount of money:

Craft Fairs—Pay close attention to your local Facebook pages, community newsletters, and school newsletters, etc., to learn about some sort of crafts fair or any festival that is taking place in your region.

Etsy—It's certainly a famous way to get consumers without needing to create your very own web page.

Facebook Groups—Always make sure that you are permitted to advertise in local groups.

However, Facebook groups are a fantastic way to boost up your company. Make sure to enter social groups of your region!

Personal Website—You may use your very own website to publish your content so that the public can see them and get in touch with you.

Social Media—Many people spend a lot of time on social media, so it is also a good platform for publishing your content there and getting the business's customers.

Personal Functions—Host and organize your personnel events at your own house!

Family & Friends circle—Once the people get familiar with your talent, they almost turn to you every time for the custom projects. Don't be shy to let others know about what you've got to offer. It will enhance the chances for you to get good business and earn some extra money. This will encourage you to work hard and spent some more time on your unit.

Conclusion

Each Cricut unit comes with a particular collection of thin and dense materials that can be cut by this unit. The thinner materials like parchment, vellum, vinyl, and several others can be sliced by many of Cricut's variants. Advanced versions can work with different dense materials, including artificial leather, hard chipboard, felt, and cloth. The amazing cutting feature of these units has made them worth the price, and, particularly for skilled artisans, they are so beneficial. In case you like to better grasp the techniques used to work with units

Now we have completed our discussion on the Cricut machine, here is the quick review or a conclusion that helps our reader get an idea about everything we have already discussed. No matter which machine you have, the basic thing that plays an important role besides deciding which machine needs to be purchased or the accessories we must need is motivation and dedication. If you have the motivation and want to do something good, then you can easily do that with the help of any variant; although there are certain necessary things, we suggest you always take a smart start and begin with less investment, as you get experience to move to the advance version.